CW01198353

Geisha & Maiko of Kyoto

Geisha & Maiko of Kyoto
Beauty, Art, & Dance

Schiffer Publishing Ltd
4880 Lower Valley Road, Atglen, Pennsylvania 19310

John Foster

Dedication

For Satomi, Kimina, Yukako, and Makiko. I hope my photographs say what words cannot.

For Inoue Satoko, Kawakami Shukichi, and Toyoda Masakatsu, friends and colleagues. I could not have done this book (or the first two) without you.

Copyright © 2009 by John Foster
Library of Congress Control Number: 2009922714

All rights reserved. No part of this work may be reproduced or used in any form or by any means—graphic, electronic, or mechanical, including photocopying or information storage and retrieval systems—without written permission from the publisher.

The scanning, uploading and distribution of this book or any part thereof via the Internet or via any other means without the permission of the publisher is illegal and punishable by law. Please purchase only authorized editions and do not participate in or encourage the electronic piracy of copyrighted materials.

"Schiffer," "Schiffer Publishing Ltd. & Design," and the "Design of pen and ink well" are registered trademarks of Schiffer Publishing Ltd.

Designed by Mark David Bowyer
Type set in Freehand471 BT / Zurich BT

ISBN: 978-0-7643-3221-0
Printed in China

Schiffer Books are available at special discounts for bulk purchases for sales promotions or premiums. Special editions, including personalized covers, corporate imprints, and excerpts can be created in large quantities for special needs. For more information contact the publisher:

Published by Schiffer Publishing Ltd.
4880 Lower Valley Road
Atglen, PA 19310
Phone: (610) 593-1777; Fax: (610) 593-2002
E-mail: Info@schifferbooks.com

For the largest selection of fine reference books on this and related subjects, please visit our web site at
www.schifferbooks.com
We are always looking for people to write books on new and related subjects. If you have an idea for a book please contact us at the above address.

This book may be purchased from the publisher.
Include $5.00 for shipping.
Please try your bookstore first.
You may write for a free catalog.

In Europe, Schiffer books are distributed by
Bushwood Books
6 Marksbury Ave.
Kew Gardens
Surrey TW9 4JF England
Phone: 44 (0) 20 8392 8585; Fax: 44 (0) 20 8392 9876
E-mail: info@bushwoodbooks.co.uk
Website: www.bushwoodbooks.co.uk

Table of Contents

Acknowledgments	4
Introduction	5
Miyako Odori, Kyo Odori, and Other Geisha Dances	21
Ochaya, Okiya, and *Ozashiki*	42
Kimina	52
Satomi	66
Yukako	80
Makiko	97
Last Days as a *Maiko,* First Days as a *Geiko*	116

Acknowledgments

Kawakami Shukichi has printed every photograph in all three of my books, and his advice and feedback have made me a better photographer. Inoue Satoko has translated all the interviews in this book from Japanese to English, and she has interpreted for me at many photo sessions and on countless other occasions. Shu's and Satoko's names are not on the cover of this book, but their fingerprints are everywhere.

In Kyoto, two families have been more than kind and generous to me. At Onaka, Toyoda Hideko has shared her knowledge and experiences with me. She also graciously offered to let me use the photographs of Onaka Suga that appear in the book. At Gionbo, Toyoda Masakatsu and Toyoda Hiroshi have given me friendship and thoughtful advice. I treasure all three of them and the time I spend at both Onaka and Gionbo.

At Ofuku, Shizuko, Mariko, and Yukari have made me feel like part of the family from the very first time I walked through the door. They have given me unwavering support when I have needed it, and they have indulged my love of coffee and chocolate. What more could I ask for? I feel like I have three families now, not just one.

Unfortunately, I don't know the names of the photographers who took the photographs of Onaka Suga, so I can't thank them or acknowledge them properly. However, the excellent quality of their work is clear to see decades later. I hope my photographs hold up as well as theirs have. In addition, Alan Cutler at Photo Rescuer did a marvelous job of restoring the eight photographs while preserving their original feel.

Finally, I have to thank my parents, Ralph and Carol Foster, for teaching me by example that you sometimes have to put someone else's needs before your own. I would not have been able to accomplish what I have if I did not understand that and the many other important things they taught me about how to treat people.

Introduction

An American in Gion Kobu and Miyagawa-cho

Look and learn.

When a young girl first steps on the path to becoming a *maiko* (an apprentice geisha) and eventually a geisha, this is one of the first things she's told. Watch how the maiko and geisha behave and act like them.

I am American, male, and my teenage years are long behind me, but I started learning about maiko and *geiko* (the term for geisha in Kyoto) in exactly the same way as these young girls. I watched and I learned. Unlike them, I was watching as an outsider, I had a camera with me, and I was a blank slate as far as geiko and maiko were concerned. I knew they wore beautiful kimono and painted their faces white. That's all. I had no preconceptions.

I started learning the hard way, by waiting and waiting for hours on the streets of Gion Kobu, Kyoto's largest *hanamachi* (geisha district). I first saw a geiko around seven in the evening on Aoyagi-koji, one of the main streets in Gion, so I incorrectly assumed that was the best time to see one. I found out later that the busiest time for geiko and maiko is from six to eight p.m. Sometimes a maiko or geiko will move from one *ozashiki* (a party where geiko and maiko perform) to another during this two-hour period, but that doesn't happen every evening. My first encounter was a stroke of luck.

Gion Kobu lanterns

Lady Luck was guiding me a lot in those early days. If I had known anything about the hanamachi, I would have known that conventional wisdom held that the best time and place to photograph maiko and geiko was in front of Ichiriki, the most famous *ochaya* (teahouse) in Kyoto, at just before six p.m., when they are leaving for their first appointment of the evening. There is a crowd of tourists and photographers in front of Ichiriki almost every afternoon of the year.

Although I passed by the famous ochaya every time I visited Gion Kobu, I didn't even know its name. I only knew that I had first seen a geiko at night, so I returned to Gion at night, usually on Friday, from about seven until ten. I was the only person on the street at those times who wasn't a customer or worker at one of the restaurants or ochaya in the neighborhood. All the tourists and other photographers seemed to disappear with the setting sun.

I'm sure that most of the people who lived or worked in Gion thought I was completely crazy, but I greeted everyone who made eye contact with me with a smile and a cheerful "Good evening!" Almost everyone responded in kind, and after a while it became clear that people expected to see me in certain spots. If I didn't appear for a few weeks, people I'd meet when I returned would ask me where I'd been. One very sweet and kind elderly woman would occasionally bring me a cold beer or ice cream bar on the hottest and muggiest summer nights to help keep me cool. I missed more than one photograph because I didn't want to touch my camera with hands covered with melting ice cream, but I was content. I knew that if the people who lived and worked in Gion accepted my presence, the geiko and maiko would eventually, too.

In Gion Kobu, street signs are embedded in the pavement.

Satomi, a geiko of Gion Kobu

11

Geiko means woman of art.

Brief Encounters

My first few meetings with geiko and maiko were frustratingly comical, even embarrassing. One night I set up my camera and tripod on a side street in Gion and waited for two hours for a geiko or maiko to appear. No one passed by me at all, let alone a kimono-clad beauty. I was tired, cold, and hungry, so I decided to get some dinner. I had just zipped my camera bag closed and was collapsing the legs of my tripod when I looked up and saw a geiko approaching me. I made a frenzied attempt to get my camera back out of the bag, but I realized I didn't have enough time and gave up. As the geiko went by, I said, "Geisha-san, why couldn't you have come five minutes earlier?" To my great surprise, she stopped. I don't think she understood what I had said, but it was clear that I was a photographer and I had missed my chance. She bowed slightly, said "Sorry" to me in English, and continued on her way. I hadn't gotten a photograph, but a geiko had finally spoken to me.

It was a small victory.

A few weeks later I had set up my camera on another side street. I hadn't been there very long when three maiko turned the corner and started walking straight towards me. Seeing and photographing one maiko in an evening would have been a major accomplishment at this point, but three – together? It was a gift from the gods. It was such a rare event that I wasn't even sure they were real maiko, so I asked them in Japanese if they were. They giggled at my imperfect use of their language and assured me they were indeed real maiko. Since they were standing right in front of my camera, I asked if I could take their photo. They agreed. I framed the shot, pressed the shutter release – and heard an awful crunching sound. My batteries had died. Mortified, I explained to the three maiko, and they thought this was hysterical. "Maybe next time," one of them said to me as she waved goodbye.

Yukako, a maiko of Gion Kobu

Maiko means woman of dance.

A Miyagawa-cho lantern

A pillar outside the Miyagawa-cho *Kaburenjo*, the theater and school where Miyagawa-cho's geiko and maiko practice their art

Disheartening to me as these encounters were, I learned a very important lesson. By this time I had started coming to Gion on Saturday afternoons as well, and I could barely get a geiko or maiko to look at me, let alone talk to me or pose for a photograph. I came to understand that a maiko or geiko would never stop on a busy street with many other people around. However, if I picked a spot away from the crowds and genuinely tried to engage them in conversation instead of immediately trying to take a picture, I might have more success.

I did.

It also helped that I started to recognize the women of the hanamachi as individuals, not just as geiko-san or maiko-san. In the beginning I couldn't tell one maiko from another, but I had been looking and learning long enough to recognize their faces. So, when I met a maiko or geiko and she didn't seem to be in too much of hurry, I would ask her what her name was. I thought some would refuse to answer me, but no one ever did. After that, I would greet them by name. If I saw them one week and took a photograph of them, I wouldn't photograph them the next time they passed by me. I would simply thank them or make small talk. Some women responded to me more than others, and if I sensed that a certain maiko or geiko didn't want her photograph taken (usually through tense body language), I left her alone. I wanted to make friends, not enemies.

Such small courtesies as greeting someone or thanking them might seem like common sense to many people, but, believe it or not, it set me apart from most of the other people photographing in Gion Kobu and Miyagawa-cho, the second geisha district I discovered. Just before my first book on geiko and maiko, *One Hundred Views of Maiko and Geiko*, was published in Japan, I was a guest at an ozashiki at an ochaya in Miyagawa-cho. One of the maiko entertaining us was one of the first young women I had met in Miyagawa-cho. She stunned some of the Japanese guests at my table when she greeted me by name. One of them asked her how she knew

me, and she replied that I was a photographer she had met several years ago. She said I had made her very happy because I had asked what her name was when I first met her and had never forgotten it.

I recently asked Yukako and Makiko, two of the women you will meet in the pages of this book, why they didn't shy away from me when I first came to Gion. They said it was partly because I didn't push them to let me take their photographs. I didn't tell them, but I was actually less likely to take the photographs of any maiko or geiko I got to know a little bit. I didn't want them to think I was taking advantage of the small friendship we had developed by always asking them to pose for me.

Differences between Geiko and Maiko

Once I was able to recognize the names and faces of most of the geiko and maiko in Gion Kobu and Miyagawa-cho, I started to notice the many differences in their appearance. Girls typically become maiko at fifteen, spend about four or five years as an apprentice, and become geiko at twenty. Their debut as a maiko is called *misedashi*, and their debut as a geiko is the *erikae*, the changing of the collar. However, a lot more than just the collar of their kimono changes when maiko become geiko. I think I can best sum up the difference in appearance between geiko and maiko by saying that when I look at a geiko, my eyes are gently guided to the unique face of that individual woman. When I look at a maiko, my eyes are bedazzled by so many bright colors that it's difficult to discern the girl underneath them all.

Both geiko and maiko use the same white makeup on their faces (*shironuri*), but their hairstyles and hair ornaments (*kanzashi*) couldn't be more different. Geiko wear *katsura*, wigs that are custom-made to complement the shape of their face. The only ornaments that geiko wear in their katsura are a tortoise shell comb (*bekko no kushi*) and a hairpin. The dark hair of the katsura serves as a frame for a geiko's white face, highlighting her distinctive features.

Kimina, a geiko of Miyagawa-cho

Miyagawa-cho is Kyoto's second largest geisha district.

15

Maiko do not wear katsura; their elaborate hairstyles are achieved with their own hair, and that hair is filled with several colorful kanzashi. Above their left temple maiko wear an ornament shaped like flowers (*hana kanzashi*) that changes every month and has a seasonal theme, for example, plum blossoms in February and cherry blossoms in April. Above their right temple perches a hairpin with dangling silver strips called a *bira*. There is usually a smaller decoration above the bira, perhaps a flower or butterfly. Yukako and Makiko sometimes wear matching golden hearts, Yukako's with a pink gem at the center, Makiko's with a blue.

As anyone who has studied composition or visual perception will know, our eyes are automatically drawn to the brightest spot in a photograph or painting first, and I find the same holds true when I meet a new maiko. My eyes are drawn to the vibrant and glittering colors of her kanzashi first, not her face.

Maiko, like Makiko, have more colorful hair ornaments than geiko.

Makiko, a maiko of Gion Kobu

17

The long sleeves of Makiko's kimono

The colors of a maiko's kimono are also more vivid than a geiko's, and the sleeves are much longer as well. The most obvious difference between the attire of maiko and geiko is the length of their *obi* (sash). A maiko's obi begins just below the girl's shoulder blades and flows all the way down to a few inches above her ankles. A geiko's obi is much shorter, covering the woman's back from below the shoulder blades to several inches below the waist.

Makiko's long obi (sash)

A maiko's footwear is just as different from a geiko's as her hairstyle and kimono are. Maiko wear thick wooden clogs called *okobo*, and one of my favorite sounds in the world is the echoing of a maiko's footsteps on the cobblestone streets of Gion. On quiet nights I can always hear a maiko before I see her because of the clop-clop of her clogs. In contrast, geiko wear a kind of sandal named zori, and more than once the sight of a geiko appearing out of a side street has surprised me. Her zori make little or no sound at all on the pavement, and before I know it she has passed by me and disappeared into the night.

Of course, there are many differences between geiko and maiko besides the visual, but I will let Satomi, Kimina, Yukako, and Makiko tell you about those differences themselves. They are far more eloquent than I.

I have spent seven years looking and learning about Kyoto's hanamachi, and my time as a photographer of geiko and maiko has paralleled the paths of the young girls who arrive in the hanamachi to become maiko and then geiko. I spent my first several months just figuring out the basics of how the hanamachi worked before I took any photographs worth saving. I then spent a little more than four years (like a maiko) working on *One Hundred Views of Maiko and Geiko*. My first book opened the doors that have allowed me to complete this book, a more personal and intimate look at my four favorite geiko and maiko and their art.

If you are reading this introduction, you have also taken your first steps on the path to understanding this incredibly beautiful world. I will give you the same advice as you flip through the pages of this book that the young girls who arrive wide-eyed in Gion or Miyagawa-cho are given:

Look and learn.

And if you get the chance, come and see for yourself.

A maiko's okobo (wooden clogs)

Miyako Odori, Kyo Odori, and Other Geisha Dances

March is a time of great anticipation in Kyoto. The days are getting longer, the weather is getting warmer, and buds start appearing on the cherry trees along the banks of the Kamogawa, Kiyamachi Street, and countless temples and shrines throughout the city.

If you take a stroll through Gion Kobu or Miyagawa-cho, you'll notice larger crowds and even more red lanterns than usual in front of the buildings. Just as the cherry blossoms are a harbinger of spring, these red lanterns are a sign that Kyoto's geisha dances are about to begin.

These dances are without question the highlight of a geiko or maiko's year. When I asked the geiko I know what they enjoy most about their profession, they responded without hesitation that it was appearing in their district's annual dance every April.

Miyako Odori

The oldest and most famous of these geisha dances is Gion Kobu's *Miyako Odori*, known as *The Cherry Blossom Dance* in English. 2008 marked the 136th annual performance of *Miyako Odori*, which started in 1872.

That first year the dance was called *Miyako Odori Jyunicho*, and it was performed in a small theater named Matsunoya, not the Gion Kobu *Kaburenjo* as it is today. One thing that has not changed from that first year is that the geiko and maiko always perform dances from Inoue Yachiyo's *Kyomai* School of dance, and only Inoue's Kyomai School.

Satomi performing in the 2007 *Miyako Odori*.

Satomi in the sixth scene of the 2007 *Miyako Odori*, "Autumn Color Leaves at the Jojakkoji Temple in Sagano"

Each year the eight dances that make up *The Cherry Blossom Dance* are unified by a theme. In 2008 the theme was Murasaki Shikibu's novel *The Tale of Genji*. In 2007, the year I photographed the odori for this book, the theme was Famous Places Rooted in the History of Kyoto. In 2006 it was Historical Scenes Illustrated by Kyomai (Kyoto Dance).

Although the dances for *Miyako Odori* are newly created each year, there are similarities in the dances from year to year. For instance, the first scene or "Prelude" always includes the highlights of all the other scenes in the program that year, and the geiko and maiko wear the famous indigo blue and cinnabar red kimono that *Miyako Odori* has become famous for.

The only scenery for the "Prelude" is a series of silver sliding doors that line the stage. These doors pay homage to the influence of Inoue Yachiyo's Kyomai School on *Miyako Odori*. Kyomai dances used to be performed in the palaces of court nobles during the Edo Period (1603-1867), and the rooms the dances were performed in then also had silver sliding doors.

Many of the other dances are based on seasonal themes. The second scene usually involves a New Year's visit to a famous shrine or temple in Kyoto like Shimogamo Shrine or Yoshida Shrine, and the sixth scene often takes place during autumn. Hence, titles of this dance such as "Fall Foliage in Togano Kozanji Temple" (2003) or "Crimson Foliage in Ononogo" (2008) include references to the maple leaves that Kyoto is so famous for. Other scenes usually have references to summer, spring, and winter in their titles, depending on that year's theme. Scene eight, the finale, brings all the dancers from that day's performance onto the stage at the same time against a backdrop of brightly lit cherry blossoms and glittering ornaments. It is truly a spectacular sight.

Satomi wearing the indigo blue and cinnabar red kimono of *Miyako Odori*.

"I had my scarf in front of my mouth and took one step, two steps," Satomi said of this moment from "Autumn Color Leaves at the Jojakkoji Temple in Sagano."

Miyako Odori runs from April 1- 30, and there are four shows daily: 12:30, 2:00, 3:30, and 4:50. The dances are the same every day, but the performers are not. One day a geiko will appear in one of the eight dances, another day she will be one of the musicians accompanying the dancers, and on a third day she might be performing the tea ceremony before the dance. If you are interested in seeing a particular maiko or geiko perform, you can purchase a pamphlet at the Gion Kobu Kaburenjo box office for 30 yen that lists which maiko and geiko are performing on each day. This pamphlet is only available in Japanese.

There are three kinds of tickets available. The first is the Special Class Ticket with Tea Ceremony that sells for 4,300 yen. This is for any seat on the first floor and the first four rows of the second floor balcony. Next is the First Class Ticket (3,800 yen) for seats on the second floor excluding the first four rows. Finally, there is the Second Class Ticket (1,900 yen) for seats on the tatami mats on the third floor.

Neither the First nor Second Class tickets include entrance to the tea ceremony before each of the day's shows. Since the tea ceremony is an excellent chance to see a geiko and maiko at much closer distances then when they are on stage (and a good chance to take a snapshot or two) I recommend that you pay the extra 500 yen for the Special Class Ticket with Tea Ceremony. It is written in English on these tickets that you should arrive forty minutes before the performance for the tea ceremony, but I always arrive about an hour before if I am going to attend the tea ceremony first. If you arrive only thirty to forty minutes ahead of time, you will have to deal with much larger crowds.

Satomi moves across the stage in the finale of the 2007 *Miyako Odori*, "Cherry Blossoms in the Kinkakuji Temple."

If you have the chance, I recommend going to the dance on two different days and getting seats in different areas of the theater. My two favorite vantage points are the center seats from the first to the fifteenth row (seats 11 and 12 on the left of the main aisle, seats 13 and 14 to the right of the main aisle) and the seats on either the extreme left (seats 1 and 2) or extreme right (seats 23 and 24) of the theater from the second row to the ninth row.

The geiko and maiko often enter the theater from the wings and move to the stage on pathways along both the left and right sides of the theater (*hanamichi*). If you are sitting in rows two through nine on the far left or right, the geiko and maiko will pass right by you, and they are so close that you can almost reach out and touch them. Unless you get the chance to attend an ozashiki at a teahouse, this is the best view you will ever have of a geiko or maiko's dance performance.

Satomi strikes a pose in the third scene of the 2007 *Miyako Odori*, "Hikone Folding Screen."

Unfortunately, if you sit on one side of the theater, you don't get as good a view of the performers on the far side of the stage. Thus, I always try to go to another show and sit in the center or the opposite side. I am always amazed at how different the scenes seem when viewed from another area of the theater. I often feel that I am watching a completely different dance even though I have seen it one or two times already.

Kyo Odori

If you take a shortcut through the grounds of the temple Kenninji, it is less than a ten-minute walk from the Gion Kobu Kaburenjo to the Miyagawa-cho Kaburenjo, home of *Kyo Odori*. Although *Kyo Odori* does not have as long a history as *Miyako Odori* (2008 was the 59th annual *Kyo Odori*) and is not quite as famous, I find *Kyo Odori* to be just as compelling, if not more so.

First of all, the Miyagawa-cho Kaburenjo is about half the size of the Gion Kobu Kaburenjo, and the seats in the first row (where I always sit) are literally right up against the stage. As a result, I feel incredibly involved with the dances since I am so close to the performers. In fact, I can actually see the floorboards of the stage quiver when a geiko stamps her feet in time with the music.

Kimina performing in the 2007 *Kyo Odori*.

Secondly, before I ever heard of geiko and maiko, I was a fan of kabuki theater. Miyagawa-cho, located a few blocks south of the Minamiza, Kyoto's famous kabuki theater, has always had strong ties to the world of kabuki. There always seems to be at least one dance in *Kyo Odori* every year that features characters with *kumadori* makeup or costumes that are clearly influenced by kabuki. When I went to *Kyo Odori* in 2005, I was surprised to see that the fourth scene that year was titled "Narukami and Princess Taema." As anyone who is interested in kabuki knows, Narukami is the title character of a very well-known kabuki play, and the character is most closely associated with Ichikawa Danjuro, kabuki's most famous actor.

Third, since *Kyo Odori* is not as popular with tour groups as *Miyako Odori*, I know that if I get to the box office about a half hour before it opens at 10 a.m., I will get the exact seats I want. Tickets for *Kyo Odori* go on sale five days in advance of the performance, and there are two kinds of tickets: a ticket with tea ceremony (4,300 yen) and a ticket without the tea ceremony (3,800 yen). *Kyo Odori* always begins on the first Saturday in April and ends on the third Sunday, so performances run for just about two weeks. There are three shows daily, at 12:30, 2:30, and 4:30 p.m.

Kimina in the fourth scene of the 2007 *Kyo Odori*, "Buddhist Goddess Benzaiten Appears at Chikubu-jima Isle"

As with *Miyako Odori*, the dances for *Kyo Odori* are different each year, but there are similarities from year to year. The first dance features both geiko and maiko, and the geiko wear their most formal black kimono. The title of this first dance usually makes reference to Kyoto or the four seasons, as in "Flowers of the Four Seasons" from 2004 and "Colorful Scenes of Kyoto" from 2006. Likewise, the title of the second dance has mentioned flowers in the title for the past four years: camellias in 2008, irises in 2007, plum blossoms in 2006, and wisteria in 2005.

The other dances in the program are a delightful balance of the comic, dramatic, and poignant. Most of the dances feature geiko, not maiko, but the crowd favorite every year (besides the finale) seems to be the dance towards the end of the program that features maiko exclusively.

The dance begins when four maiko seated on a platform glide onto the stage. Three of the maiko are playing different types of drums or percussion, and the fourth plays the flute. Gasps of wonder ripple through the theater when these four maiko are joined on the stage by a larger group of maiko dancers.

Kimina in the fifth scene of the 2007 *Kyo Odori*, "Dance of Flowery Beauties"

At the end of the scene, two of the senior maiko move to the center of the stage and toss folded kerchiefs into the crowd, a wonderful souvenir for a few lucky audience members. Each kerchief has been autographed by the maiko, who usually includes a cute drawing or brief message as well.

The grand finale of *Kyo Odori* is "*Miyagawa Ondo*" ("The Miyagawa Anthem" or "Miyagawa Dance Song"). It begins quite comically with four geiko tiptoeing onto the stage, playfully keeping their faces hidden behind their fans. After a few moments the stage lights go up, and these four geiko are joined by all the other geiko and maiko who have performed that day. Like the *Miyako Odori* finale, it is an unforgettable site.

The programs for both *Miyako Odori* and *Kyo Odori* have brief descriptions of the dances in English. More important to most fans, they have photos of all the current geiko and maiko with their names in both Japanese and English, a valuable reference source.

Kyoto's other three geisha districts (Kamishichiken, Ponto-cho, and Gion Higashi) also have annual dance performances. *Kitano Odori*, Kamishichiken's main dance, takes place from April 15 - 25, and Ponto-cho's *Kamogawa Odori* is held from May 1 - 24. The only odori not held in April or May is Gion Higashi's *Gion Odori*, which occurs from November 1 - 10. Each geisha district has a unique style of dance, and all five events are definitely worth seeing.

Kimina in the finale of the 2007 *Kyo Odori*, "Miyagawa Ondo"

33

Onshukai and Mizuekai

Gion Kobu and Miyagawa-cho also have dance performances in October, *Onshukai* in Gion and *Mizuekai* in Miyagawa-cho. However, these dances are quite different from *Miyako Odori* and *Kyo Odori*.

To begin with, *Onshukai* lasts for only six days (October 1 - 6) and *Mizuekai* only four (October 11 - 14 in 2007). Next, ticket prices are significantly higher for these October dances. A reserved ticket for *Onshukai* is 8,000 yen, and the best seats for *Mizuekai* are 6,000 yen. Of course, since these performances last for only a few days and there is one show a day, not three or four, tickets are harder to come by.

Finally, both *Miyako Odori* and *Kyo Odori* run for almost exactly one hour, with just a few seconds between scenes. *Onshukai* and *Mizuekai* performances run for a few hours, and there are breaks of at least twenty minutes between some dances.

Kimina performing in the 2007 *Mizuekai*.

What makes both *Onshukai* and *Mizuekai* interesting to me is the fact that neither is the big tourist attraction that the larger dances are. Consequently, there is a more relaxed atmosphere, and the focus is on the dancing, not the spectacle. Audience members tend to be aficionados, not just casual tourists. In addition, geiko and maiko are just as likely to be spectators at these dances as they are performers.

The first time I went to *Onshukai*, I was very surprised to see several of Gion Kobu's geiko and maiko sitting in the audience. I was even more surprised when I went into the lobby during one of the longer intermissions and found the same geiko and maiko casually chatting with other theatergoers, and no one was paying them much attention. That would definitely not happen during *Miyako Odori*.

Another moment from "Miyagawa Kouta"

Kimina dancing in "Miyagawa Kouta." At this moment, the lyrics are "I am very fond of you."

36

37

These October dances are also a chance for younger maiko and *shikomi* (girls in training to be maiko) to watch and learn. I waited too long to get my tickets for the 2007 *Onshukai*, so I ended up sitting on the tatami mats on the third floor of Gion Kaburenjo. I was as far away from the stage as I could get and still be in the theater. Sitting on the tatami mats right in front of me were two shikomi, and both girls were obviously thrilled to be watching the dances. Moreover, when the lights went down and the first dance began, three junior maiko slipped into the theater and watched from just inside the door.

I had a similar experience at *Mizuekai* last year. I was sitting in my usual front row seat at one of the performances, and I was surprised to see that the two seats next to me on my right were unoccupied since the theater seemed to be almost sold out. Then, just a minute before the first dance was set to begin, two first-year maiko in full makeup squeezed by the other audience members in the row and shyly sat down next to me. I'm sure when I attend *Mizuekai* this year, they will be performing in one of the dances, not just watching it.

Kimina in the scene from spring in the 2007 *Mizuekai*

Preparing for *Miyako Odori*

As I mentioned earlier, *Miyako Odori* is the biggest event of the year for geiko and maiko in Gion Kobu. *The Cherry Blossom Dance* begins in April, but preparations begin as early as February. I spoke to Yukako and Makiko, two maiko from Gion Kobu, about what the rehearsal process is like.

Question: Yukako-san, Makiko-san, when do your rehearsals for *Miyako Odori* actually begin?

Makiko: "Since some girls are often called in for work in the daytime, it is very difficult to gather all the girls together at the same time. So all of us really have to concentrate on these intensive classes for a short period of time. Most of the time, these intensive lessons take place in March."

Yukako: "In February and March we intensively concentrate on certain songs, try not to accept any work during the daytime, and stay in the area. We adjust our schedule for our group lessons. Well, actually, it only takes two days to memorize."

Yukako in the fourth scene of the 2007 *Miyako Odori*, "Watching Fireflies in the Kiyotaki River." She said, "The dance shows a girl trying to catch a firefly with a bamboo branch, and it is very adorable."

Makiko: "Right, we do it all in two days."

Yukako: "Our teacher will teach us all the movements in two days. Then we start to work on memorizing it gradually after that. The next process is polishing it up. It truly is a crash course."

Makiko: "By the middle of March, we start practicing on the stage. So by that time, we need to have it under our skin. That's why we ought to perfectly memorize it by heart."

Yukako: "Maiko who have just become maiko are most likely not included in playing a musical instrument in *Miyako Odori*. They normally practice musical instruments in February. As a result, these girls have no chance to listen to the music until the intensive two-day dance class in March. In this case, these girls have a tremendous disadvantage because they do not know how the music goes when they are trying to learn the dance, which should be in synch with the music playing in the back.

"Both of us are playing music in *Miyako Odori*, so we know how the music goes. For example, how the music starts for spring, and the summer scene starts with this note, or the winter scene goes like this... Even when you don't know the song, you still need to memorize the dance and also learn about the music at the same time. It is not like modern pop music that we dance with. You truly need to know the timing and the ambiguous air in between the sounds of the samisen. And also the words of the song."

Question: Not all of the maiko can memorize everything right away, can they? What about the girls who just cannot get it?

Yukako: "We learn everything in two days."

Makiko: "After that class, we go back to the *okiya* (a house where maiko and geiko live), then..."

Yukako: "We ask *onesan* (older maiko or geiko), 'Onesan, could you please check this part of the dance?' Or I write it down. Yes, we write down what we learn. There are no names for each movement, but we try to write it out in a way that we can understand."

Makiko: "Like, 'to stamp feet.'"

Yukako: "Say, here we go 'stomp' or 'stomp, stomp.' Or 'right foot back' or 'at left...' It is all like a code. Only you yourself can understand it. We write down everything like that on paper and go back to the okiya. You just write down key words in the class, but you have to rebuild that code at the okiya to understand."

Makiko: "When we are back at the okiya, the girls get together with onesan to check and fill in where we missed or reconfirm what we've got. By doing this, we memorize the entire performance. We do this so that we can catch up before attending the next day's class."

Yukako: "As a group dance, there are various age groups of girls, and they all do the same dance in the same performance, from sixteen-year-old maiko to forty-year-old onesan."

Makiko: "Of course, the differences in experience and technique are pretty obvious. For the girls who have no idea about what we are learning right now, and for onesan who have done it so many times... Knowing the difference between these seasoned dancers and us, we have to make an extra effort to catch up with everybody."

Question: Are there some girls who are left behind?

Yukako and Makiko: "Yes, there are."

Question: Are they given some help?

Yukako: "This is it. This is what is very difficult. It is not just the onesan offering an extra lesson. It is the younger girls who must say, 'Onesan, could you please spare some time to teach me the dance in the places I am not certain about?'"

Makiko: "We are not real sisters or classmates. It is work. So this is a part that is very severe and real about our world. The younger has to approach the seniors spontaneously, otherwise..."

Yukako: "You don't appear without good faith. For example, say Maki-chan (Makiko) cannot remember all the dance movements. Suppose I have it perfectly. I don't go to Maki-chan, 'Come to see me. Since you don't seem to get this part, I will give you a little extra lesson.' Even when the older approaches the younger like this, if the younger replies that she is fine, then that's it.

"The younger needs to go to the onesan even when she thinks she's gotten it all perfect. Like, 'Pardon, Onesan. Could I please have you check my performance now?' This is good faith. You need to show a humble and full-hearted attitude."

Makiko: "Right. Since you are going to take the precious time of others for yourself, you have to show sincerity when you ask. It is work. This is all in a professional world."

Yukako: "So even if we are very close, it is the same. We teach each other, we ask onesan. It is okay if you are perfect and confident, but it does not work like that."

Makiko: "These girls who are likely to be dropped out will know by themselves since they are yelled at in front of everybody. Since you really cannot bear the pressure of the shame, you really try hard for dear life. It is usually the same girls in a big group like this. In this case, onesan from the same okiya feel ashamed as well. If our little sisters are pointed at, then we feel responsible to tell her.

"Also, by having the teacher scold one girl, she disturbs the entire group's practice. You really don't want to trouble everybody. So we work desperately. By doing this, we gradually memorize everything perfectly. Therefore, I work so hard to memorize for a short period. When I finally get it, I realize that I can do this much in such a short period of time! Why can't I memorize a dance in normal daily practice then? I wonder..."

Makiko in "Autumn Color Leaves at the Jojakkoji Temple in Sagano." Makiko said, "This is the gesture of writing a letter."

41

Ochaya, Okiya, and Ozashiki

The three words I found most confusing when I started learning about the world of geiko and maiko are ochaya, okiya, and ozashiki. The brief explanation is that an ozashiki is a party where geiko and maiko entertain guests, and these parties are held at an ochaya (teahouse). An okiya is a house where maiko and geiko live. However, as with many things connected to Kyoto's hanamachi, things are not as simple as they first seem.

In order to get a clearer view of what exactly ochaya and okiya do, I spoke to Toyoda Hideko, the *okasan* (mother of the house) of Onaka, an ochaya in Gion Kobu that first opened seventy-three years ago. Onaka takes its name from Onaka Naka, who was born in 1900 and had her misedashi as a geiko named Kotaro in 1909. Naka had her first daughter, Suga, when she was twenty. Suga had her misedashi as a maiko when she was ten years old, five years earlier than the maiko of today, who make their debut at fifteen. Suga's name as a maiko and geiko was Komanryo. Onaka Naka opened the teahouse Onaka in 1935. She was thirty-five at the time.

Komanryo (Onaka Suga) soon after she became a maiko.

During World War II, Gion Kobu's ochaya were closed, but Onaka Suga reopened Onaka on October 25, 1948, and the ochaya has been in business ever since. In 1978 Onaka expanded with the opening of Gionbo, a "home bar." A home bar is a small bar connected to an ochaya where customers can go for drinks and snacks.

Onaka Naka died in 1961 at the age of sixty-two, and Onaka Suga died in 1992 when she was seventy-two. At that time, Onaka Kyoko, Suga's adopted daughter, took over Onaka. Kyoko got married two years later and gave birth to her first daughter in 1995, so she decided to take a break from the business. She asked her biological mother, Toyoda Hideko, to become the okasan of Onaka, and Hideko has been running Onaka ever since.

Komanryo and another maiko pose with *hanagasa* (flower hats).

Question: Okasan, Onaka has been in business for more than seven decades. Which of those decades has been the best for the hanamachi?

Answer: "Gion was most prosperous when the Taisho Emperor assumed the throne in 1915, a few years after Onaka Naka had her misedashi. At that time, there were 300 ochaya in Gion Kobu, and 800 geiko and 300 maiko."

Question: What was the most difficult decade?

Answer: "The most difficult time the hanamachi experienced was during World War II. All the ochaya were banned from operating and maiko and geiko went away from Gion."

Question: What has been the biggest change in the hanamachi from Naka and Suga Onaka's time until now?

Answer: "Due to the low birthrate, there have not been enough children in Gion."

Onaka, an ochaya founded in 1935.

Shoki, a demon slayer from Japanese folklore, guards the entrance to Onaka.

Question: What is the difference between an ochaya and an okiya?

Answer: "An ochaya is a place that provides the space and dinner for clients who come to see the performance of geiko and maiko. Also, on a client's demand, an ochaya can make arrangements to send maiko and geiko to other ochaya. Most importantly, an ochaya must keep the traditions of Gion Kobu and protect maiko and geiko.

"An okiya provides maiko and geiko with a place to live, the necessities of living, and expenses until a geiko becomes *jimae* (independent). Basically, an okiya functions as a family of geiko and maiko while they live there as the okiya's daughters.

"In addition, an okiya will send maiko and geiko who belong to the house to perform at an ochaya, but only when they receive a request from an ochaya. An ochaya can be an okiya at the same time, but an okiya cannot run the business of an ochaya. Okiya cannot deal with customers directly or send maiko and geiko to customers."

Ofuku, one of the newest ochaya in Gion Kobu

Yukako in front of her okiya, Nishimura

The name plaques for Danka and Fukue next to Onaka's entrance. The oval sign at bottom right shows Onaka's membership in the union of Gion Kobu.

The name plaques for geiko and maiko above the entrance to Nishimura. Yukako's name is fourth from the right, and Makiko's is third from the right.

Question: You run an ochaya, but the names of two geiko are on plaques next to your door like an okiya. How did these geiko become connected to your ochaya?

Answer: "Maiko and geiko belong to the okiya who raises them until they can be on their own. After they become geiko and start to live by themselves, they still need to belong to either an okiya or an ochaya, but the house no longer covers their living expenses. It is called *misegari*. It is just like models belong to an agency to get work. Girls can pick any okiya or ochaya they like. Most of them follow their onesan's advice.

"Right now, Onaka has two geiko that belong to the house. One is Fukue, who has lived here since she was a maiko. She is a geiko of *tachikata* (a geiko who dances). The other is Danka, who used to belong to another ochaya but moved to Onaka. She is a geiko of *jikata* (a geiko who plays the samisen and sings). Their living expenses are separate from the house. It is not so uncommon to have geiko and maiko at ochaya."

Question: How many ochaya and okiya are there in Gion Kobu now?

Answer: "As of today, May 12, 2008, there are seventy ochaya and eighteen okiya or *yakata*. There are ninety-eight geiko and forty-three maiko in Gion Kobu now as well. To give you an idea of how today compares to times gone by, from 1818 until 1829, there were 700 ochaya and more than 3,000 geiko and maiko. In 1915, there were 300 ochaya, 800 geiko, and 300 maiko. After World War II, the number of geiko and maiko decreased to 360, and by 1950 there were 218 ochaya and 330 geiko and maiko."

Question: Do you hire geiko and maiko from all the okiya in Gion Kobu, or are there some okiya that you have a special relationship with?

Answer: "Onaka can request any geiko and maiko who belong to Gion Kobu ochaya and okiya when we receive a request from our clients."

Question: I'd like to talk a little bit about ozashiki and what an ochaya does to prepare for them. As an okasan, what are all the things you do to organize an ozashiki?

Answer: "Once we receive a request from a client, we ask several questions and take many steps. First, what is the purpose of the party? Is it to entertain our client's customers or our client himself? Then we confirm the date and time. Then we have more questions. How many people will be at the party? What is the time frame? Between 6 p.m. to 8 p.m.? Which restaurants would they like to use to cater the food? What kind of food would they prefer? How much are they willing to pay to cater the dinner?

"Next, we advise the client about how many maiko and geiko would be a good number for the party. For instance, instead of having two geiko, let's have one geiko and more maiko. On the other hand, maybe they don't need that many girls to perform, so let's cut some maiko.

"After that, we think about what a geiko's hairstyle should be. Should she wear a katsura, or should she just wear her hair up? Depending on what songs a maiko or geiko will dance, should we have an older jikata or a younger jikata, who will be less expensive? We consider these points and calculate the estimates. Then we contact the client to confirm.

"When the client accepts the plan, we make arrangements with maiko and geiko through an ochaya or okiya, and we contact the restaurant and make arrangements about the menu and the price. When each ochaya and okiya receives the reply from the maiko and geiko and confirms the schedule, we call the client to let them know that the arrangements have been made and we are ready to set up the party. We reconfirm with the client about the date, time, and the number of people we will receive on that day.

Komanryo sits for a formal portrait.

Komanryo strikes a pose. Although she is no longer a first-year maiko, her upper lip is still not painted red.

Komanryo as a senior maiko

Komanryo as a geiko

"One day in advance, we reconfirm with the ochaya and okiya about the geiko and maiko they are going to send us. Also, we let the maiko and geiko know which songs or performance they will present at the party. The show is all arranged by the *okami* of Onaka to suit the purpose of the party. (Geiko and maiko call the mother of the house okasan, but customers call her okamisan).

"In the morning on the day of the party, we call the restaurants to tell them the exact time to bring the food. All the food provided at the party is coming from restaurants.

"Then the okami of Onaka will instruct others to receive the guests, and we make the final checks. We make sure the *zashiki* (the room for the party) is properly cleaned. We check the drinks, cups and glasses, and toilet. We see if the air conditioner is working properly and adjust the temperature. We make sure the flowers in the room are ready and that the paintings and *kakejiku* (hanging scroll) are proper for the season. Then we confirm that the gifts

Komanryo (far left) and three friends in a *Miyako Odori* portrait

for the guests are ready and that car arrangements are in place for when the guests leave. Finally, we mentally prepare for some unexpected or unwanted situation or trouble in order to quickly deal with it."

Question: What is a geiko's role at an ozashiki?

Answer: "A geiko performs all the things she learned at *Yasaka Nyokouba Gakuen* (a school for maiko and geiko) and maintains the good traditions and customs wherever she is.

"At the party, if the ozashiki is a client's private party, then it should be for the sake of the client's amusement. But if the client is having a party to entertain his clients, then she should proceed accordingly."

Question: What is a maiko's role?

Answer: "Maiko also have to do the above, and at the same time, they are the assistants of the geiko and also brighten the atmosphere of the party just by being there. After all, for all of us – maiko, geiko, and ochaya – our job is to provide the clients with the service of assiduities."

Komanryo as a geiko posing for a dance portrait.

Question: What in your opinion is the biggest difference between geiko and maiko besides the obvious differences in their appearance?

Answer: "A maiko can only learn so much about all the things she learns in different classes, but when she becomes a geiko, she will know which of the performances she is good at and want to learn more.

"All the expenses of a maiko are taken care of by the yakata (another name for an okiya), but once she becomes a geiko, she will have a lot of different business and personal relations with the outside world and will have to pay for all her expenses, from living to business expenses."

Question: What do you think the future will hold for the world of geiko and maiko? Do you think your granddaughter will succeed you as okasan of Onaka one day?

Answer: "The life and surroundings of maiko and geiko will change even more in the future. First, there won't be any kids who are born and raised in an okiya. Generally speaking, this will be due to the low birthrate in Japan. In addition, because there will be no children and because of the inheritance tax, a lot of ochaya and okiya will go out of business. The present ochaya have fewer and fewer original clients, and they are starting to collect new clients from the Internet. It is just selling the name of the ochaya, but there is no tradition.

"As for Onaka, at this moment, my daughter will take the business over from me. I have no idea if my granddaughter will take the business in the future, but I have a small wish to have her keep the business for the generations to come."

Yukako in the zashiki
(banquet room) of Onaka

Kimina on the veranda of Onaka

51

Kimina

She's more beautiful in person than she is in my photo.

That's what I was thinking as Kimina glided across the room to meet me. My interpreter (Inoue Satoko) and I were visiting several okiya in Miyagawa-cho that afternoon to get permission from maiko and geiko to use their photographs in *One Hundred Views of Maiko and Geiko*.

I was a bit nervous about asking Kimina because I didn't know her at all. In fact, in the four years I had been working on *One Hundred Views*, I had only two photographs of her. Our paths simply did not cross much, so I had never had the chance to introduce myself to her or even ask her name.

My trepidation vanished the second I saw Kimina. Because my Japanese is far from perfect, I often focus on a person's body language, facial expressions, and tone of voice just as much as the words they are saying. I didn't catch exactly what Kimina said to Satoko and I as she approached us, but it was clear from her smile and posture that she was welcoming us quite warmly.

I let Satoko explain about the book. Again, since I did not understand all of what Kimina was saying, I was concentrating on *how* she said things, not *what* she said. We only spoke to Kimina for a few moments, but in those few seconds she had me completely spellbound. She had an energy, a charm, a glow… The way she smiled, the way she laughed… It is hard for me to put into words, but Kimina somehow seemed more alive than the rest of us.

53

With every emotion that flickered across her face, with every gesture she made, she radiated joy at being alive – and she seemed completely unaware of it.

When it came time to ask geiko and maiko I knew about appearing in this book, I wasn't sure if I should put Kimina on the list or not. I had known Satomi, Yukako, and Makiko for several years already, so I knew they would be comfortable with me photographing them. I had met Kimina only once, but she seemed so open, so unself-conscious, and so comfortable with who she was that I was sure I could take some amazing photographs of her. It took a little time to get in touch with her, but she said yes immediately.

I wanted to break the ice with her as soon as possible, so I scheduled my first session with her for a few days later, at the end of February 2007. I was eager to get started on this new book, but I was a little worried about how Kimina would react to me. From what people tell me, my style is completely different from most Japanese photographers. How would she respond to me and my less-than-fluent Japanese?

Since Kimina is one of the busiest geiko in Miyagawa-cho, I only had twenty-five minutes to photograph her that first day. I briefly explained what I wanted to do, and then I just dove in and started shooting. After snapping off a few frames of film, I asked her if she liked Doraemon, a popular children's cartoon character in Japan. I was hoping the absurdity of the question would provoke a smile. Kimina burst out laughing, and from then on we were on our way. My only worry was whether I had enough film to capture all the incredible moments I was seeing through my lens or not. Fortunately, I did.

I think the photographs I took of Kimina that day and at our other sessions capture her beauty and vitality more than any words can. I hope you – and she – agree.

Question: Kimina-san, I'd like to begin by talking to you about the 2007 *Kyo Odori*. How long before the dance did you start rehearsals?

Kimina: "I started to practice for the 2007 *Kyo Odori* from February. When I start to practice depends on the role I dance. This year, I started a little later than usual since I did not have the group dance that we do in the first part of the program."

Question: What is a typical rehearsal like?

Kimina: "The rehearsal we call *ohzarae* starts from the morning and ends around four in the afternoon. We go in around 8 a.m. to wait for our turn to put makeup on. We do the rehearsals exactly like the performance. We put makeup on and change costumes for each dance and go up on the stage just like the way it goes on the day of a performance."

Question: There is no instruction from the director on the day of the ohzarae?

Kimina: "That happens way before the rehearsal. After performing the entire act without any pauses, there are some comments made by the director about the costumes, but anything else was already done before."

Question: Who is the director?

Kimina: "The person who directs the rehearsal is Sensei Tanimura Yosuke. He leads the rehearsal and talks with all the other teachers for dance, song, the instruments, and so on."

Question: Although the dances in *Kyo Odori* are the same each day, the performers change depending on the day. I saw you dance in two different dances, and I believe you danced in a third as well. You also performed in the finale many days. So, you had to learn four different dances. Was it difficult?

Kimina with a *tenugui* (scarf)

Kimina: "Well, it depends on the role I play. Most of the time, the dance is about a regular human lady or a geiko, but this year I had to be Benzaiten, a goddess. It was very different from what I normally dance. No movement at all. The teacher normally tells you something like, 'Lower your shoulder, move your head a little bit to be more lady-like…'

"However, with this goddess role, the teacher told me not to move my face. I had to be goddess-like. So, the difficulty of dancing multiple songs is solely up to what kind of roles I have to do. The more different characters you have to dance, the more it gets to be difficult."

Question: How do you begin to learn each dance?

Kimina: "First, the teacher shows me the movements. Then after I have learned all the movements, I will dance with the sound of the samisen."

Question: The first dance I saw you perform in, "Dance of Flowery Beauties," was very upbeat and had a comic touch. Could you tell us the story behind it and who your character was?

Kimina: "This song is a folk song from the Tango District in Kyoto called 'Miyasubushi.' The girl I performed is a geiko."

Question: Your hand gestures in this dance were very interesting. For example, you were often twisting your hands as if you were pulling on something. What were you supposed to be doing?

Kimina: "This gesture means I am rowing a boat. It is very difficult. I had a hard time getting it right."

Question: You've already mentioned the second dance you performed in, "Buddhist Goddess Benzaiten Appears at Chikubu-jima Isle." It seemed to me that the dance had a very strong influence from kabuki. What is the story behind it?

Kimina: "There was a king, and he went to Chikubu Island to pray to the gods before he went to war. Benzaiten is the goddess and Dragon is the god. The gods give the king the power to win the war. As I said, the one I played was Benzaiten, the goddess."

Kimina as the goddess Benzaiten

Kimina "rowing" in "Dance of Flowery Beauties." "This is a song performed a lot at ozashiki," she said.

57

Question: The orange kimono and elaborate gold crown you were wearing looked stunning, but I'm sure they were both quite heavy. How did your costume and props affect your movement?

Kimina: "I carefully shuffled and kept my center of gravity lower and moved extra slow in order to keep my hair ornaments still while I was performing. If I moved too much, then the hair ornaments would start to swing right and left. I had to avoid that."

Question: The finale of *Kyo Odori*, "Miyagawa Ondo," is an amazing sight since all the geiko and maiko appear on stage at the same time. How aware are you of the other geiko and maiko when you are dancing?

Kimina: "I can see other people dancing next to me while I dance. This is a group dance, so I have to check out of the corner of my eyes to place myself at the right spot. It is not easy to perform with all the geiko and maiko together like this. It is hard to perform all together in good order. We practice over and over."

Question: Of the four dances you performed, which was your favorite role?

Kimina: "Benzaiten. It has a very unique style that I never danced before."

Question: Who decides the roles you play? Is it the okasans or the director?

Kimina: "It is mainly the dance teacher and the upper members of the union. They try to see who can do such and such role and be very fair to all of us."

Question: Are the opinions of the okasans of the okiya reflected in the decision?

Kimina: "No. Nobody knows until the time it is publicly pronounced."

Question: I did not realize the union has that much to do with who plays what.

Kimina: "Well, you know, the members of the union are still the okasan or *otosan* (father of the house) of ochaya. So the head of the union and the two other chairs and the grand master together decide everything, I have heard. It is by turns, but sometimes it goes like, 'She is supposed to do this part since it is her turn, but the other one can do better so let's put her instead…'"

Kimina in "Miyagawa Ondo." "It is a very glamorous finale."

Question: I recently saw you dance in *Mizuekai*, Miyagawa-cho's autumn dance performance. On the first day you appeared in a dance with quite a few props. At the beginning you were dancing with an umbrella, and later you were dancing with a fan. Do you enjoy dances like this where you perform with props, or do you prefer dancing without them?

Kimina: "I really enjoy being able to use different types of props since once you become a geiko, you don't get to use many props except for a fan and scarf in day-to-day ozashiki performances. For example, an umbrella. It looks too cute for a geiko to perform with an umbrella, so maiko get to use them but geiko do not.

"Once at a practice, the teacher let me use an umbrella. When I opened it, out came a wind of cherry blossom petals! 'How beautiful,' I thought. But at the recital, the prop I was supposed to use was changed to something else, so I was very disappointed. The teachers decide what to do at the performance when they are giving us a lesson."

Kimina in the autumn scene in *Mizuekai*

Kimina in the spring scene in *Mizuekai*

Question: I notice that you always wear a unique silver hairpin with a pearl in it. Where does it come from?

Kimina: "My onesan gave me this. I take care of it."

Question: Can you describe what a typical day is like for you?

Kimina: "I wake up around 9 a.m. At 11 a.m., I go to lessons. Around 1 p.m., I go out to greet the people who took care of me the day before. At about 4 p.m., I start to prepare for work, and then from 6 p.m., I go to work. I go back to my place between 11 p.m. and 1 a.m. My free time? Well, it depends on the lessons. Sometimes the practice is very long; other times, short. Some days I have all three lessons in one day. It really depends."

Question: What do you mean by "greeting people who took care of me the day before"?

Kimina: "I go out to see the ochaya that called me the day before or go to see my seniors or to visit people that I simply need to talk to. Since I am not a first-year maiko, I don't have to visit every single ochaya and say, 'Good day, *Okasan, mata otano shimasu.*' (It means 'please,' but what it really means is 'please remember my face and my name.') They have to do this routine since they want the owners of the ochaya to remember their names. If some client asks the okasan to call a maiko, they want to be the one to be called. It is very important to show your face like that.

Kimina in May 2007

"Once I am up on the stage, I forget all the bad things."

Kimina as Murasaki Shikibu in the 2007 *Jidai Matsuri*. Jidai Matsuri, held every year on October 22, is one of Kyoto's three biggest festivals.

"As geiko, we don't need to do that anymore. We only have to visit the ones we have a good relationship with and someone who asks us to visit them for certain reasons."

Question: You mentioned that on some days you have three lessons, but on other days you don't have as many. How does that work?

Kimina: "Our *nagauta* (long song) teachers all come from Tokyo. There are three of them that come together. Our dance teachers are in Kyoto, but the *ohayashi* (traditional Japanese percussion) teacher is from Tokyo. So, the teachers from Tokyo pick a day they are all available and decide to come to Kyoto. For example, for today, the schedule for dance lessons is all set up, but the nagauta teachers show up at the same time. What we do then is we have maiko start with dance classes, and while they are doing that, we geiko do nagauta. Still, sometimes we cannot attend all the classes that happen at the same time."

Question: How long does each class last?

Kimina: "About one hour for a group lesson, but a lesson for individuals only goes for fifteen to thirty minutes for nagauta and ohayashi. Dance lessons for an individual can last forty minutes. Lessons are very short for each of us, so we really need to review a lot by ourselves after we get back to the okiya. Otherwise, we cannot remember anything."

Question: What is your definition of a geiko and maiko?

Kimina: "A geiko is treated as a grown-up. We have to take responsibility for ozashiki and any classes and practices. A maiko is regarded as a child. She will still need some grown-ups to take care of her."

Question: What do you enjoy most about being a geiko?

Kimina: "Being on stage. There is a time when the practice is so hard that I cannot enjoy it much, but once I am up on the stage, I forget all the bad things."

Question: What adjustments did you have to make when you went from being a maiko to being a geiko?

Kimina: "Since I started as a geiko, it has been seven years since I started. In Miyagawa-cho, once you become eighteen years old, you are allowed to perform as a tachikata, who dances instead of singing in the back as a jikata. I started when I was nineteen years old."

Question: What made you decide to become a geiko?

Kimina: "It was when I was in elementary school. I saw a beautiful maiko in my grandfather's magazine. I was so moved by her beauty. Then right after that, I saw a documentary on a little pre-maiko girl who was getting ready to be a maiko. I thought, 'This is it!' I can wear a beautiful kimono, I can learn to dance, and I also get paid for doing it. It is shooting three birds with one stone.

"I declared to my parents that I would become a maiko after I graduated from junior high school. They thought I was simply being silly. They also told me that whatever I see on TV is only a part of what it really is. After junior high, I wanted to go to Kyoto to become a maiko, but I was not able to. I quit high school before even finishing the first year and stayed in Kyoto for half of that year. The same ochaya that I belong to now.

"Then I thought I should go to college instead of being a maiko. So I went back home to study to get a high school certificate. After I got the certificate, I could not find any college that I was interested in. So I was lost again. Coincidentally, someone who knew my Kyoto okasan contacted me and told me to follow what I really wanted to do. And then, I finally made the decision for good."

Kimina in May 2008

Question: Was it difficult to start as a geiko, not a maiko?

Kimina: "In order to fill in the years of being a maiko, I had to practice at least twice as much as other girls. I had to take special lessons to catch up. I needed to know all the dances that maiko know, and, on top of that, I had to know the geiko dances.

"Since I made my debut as a first-year geiko, I had many maiko who started before me that I had to call onesan. This was hard for me, especially in front of clients. They all asked me why I was calling the little maiko 'Senior.' The clients thought it was very awkward. Once all those maiko graduated to become geiko, then I no longer felt pressure by calling them onesan. Since they were geiko, clients wouldn't wonder about me calling them onesan."

Question: I read in another interview that you didn't tell your father you were going to become a geiko. How does he feel now?

Kimina: "When I told my father a lie about going to Kyoto... Instead of going to Kyoto for college, I went to an okiya. My mother told him. He was very surprised that he had been tricked. However, I had been working very hard for a year and my mother and my sister showed him some photos of my recital, so he finally agreed to what I do. He takes it as I was married to the geiko world and as long as I do my best here, he will support me."

Kimina in "Miyagawa Kouta." "The words are elegant and colorful to suit the hanamachi."

Question: How has your understanding of a geiko's art deepened since you started?

Kimina: "When I realize something that I did not see the year before or understand what the teacher meant to say about a performance, I feel that I have improved a lot."

Question: Is there anything else you'd like to say about a geiko's art to the people reading this book?

Kimina: "There are many things that I want to say, so it is hard to articulate them all. I have seen a lot about geiko and maiko on TV and in magazines. I read them and think, people who read these things might automatically believe that what is written is all about us. I'm not saying that what is written about us is all wrong. However, there are a lot of things the author cannot write. Some don't write about those issues, but others skimp about these issues.

"It is hard to articulate since we live in a small society (hanamachi), so it may be difficult for regular people to understand everything. I appreciate the movement of the media putting a spotlight on us lately. I think there is a new trend to save the traditional maiko and geiko world in society right now. If you come across something that you don't understand when you read about us, please come and see us in Kyoto. There are more and more chances for regular people to enjoy our performances. Please come and see us."

"A geiko is treated as a grown-up. We have to take responsibility for ozashiki and any classes and practices."

Satomi

I first saw Satomi as she was walking down Aoyagi-koji in Gion Kobu on a Saturday afternoon early in 2003. I quickly raised my camera to my eye, framed the shot, waited for her to get a little closer...

And almost dropped my camera.

Satomi had stopped to pose for me. In the few months I had been trying to photograph geiko and maiko, none of them had ever stopped to pose for me without my asking them, and even then most simply ignored my request. I was so shocked that I almost forgot to take the picture, but I did. I thanked Satomi, and she went on her way to her evening's engagement.

Our encounter had lasted only a few seconds, but I knew one thing for certain: Satomi was a very special geiko.

Over the next several months, I seemed to meet Satomi almost every time I was in Gion. Sometimes I took her photo, but other times I just said hello and we chatted for a moment or two. At the end of July, I went to Gion one last time before I returned to New York for summer vacation. Sure enough, I met Satomi. I told her that she wouldn't see me for a month because I was going home to visit my family. I realized that she probably wasn't particularly interested in my life, but the only thing I could share with her was a few details about who I was and where I was from. It wasn't much, but she had shared a part of herself with me each time she had let me photograph her. I felt I should do the same.

67

When I returned in September, I saw Satomi walking down Aoyagi-koji again. She nodded to me and said, "*Okaerinasai*." Welcome back. An expression said thousands (if not millions) of times every day all over Japan. To me, however, the words had a much greater significance. To me they meant that to one person at least, I had a place in Gion. I was welcome there. I felt a tremendous sense of relief and a new resolve. If I was patient, polite, and persistent, my seemingly impossible goal of publishing a collection of photographs of Kyoto's geiko and maiko could become a reality.

Thank you, Satomi. Thank you very, very, much.

I have never shown that first photograph of Satomi to anyone, but it is one of my prized possessions. If you saw it, you probably wouldn't think much of it, but it is an important record in the history of my life. I can look at it and say, "Right here. This is a moment when my life changed."

Question: Satomi-san, I'd like to begin by talking to you about the 2007 *Miyako Odori*. How long before the dance did you start rehearsals?

Satomi: "The practice starts at the beginning of March. The length of the practice depends on each scene. For example, *so odori* (a group dance) or *nakabasami* (a shorter dance between scenes)."

Question: How long are the rehearsals for each of those kinds of dances?

Satomi: "In order for all of us to dance in perfect order as a group in so odori, we practice over and over. We encourage and teach each other throughout. For nakabasami, we ought to memorize the whole thing in three to four days of classes."

"A shot from one March afternoon, right before I am going to an ozashiki. I'll do my best!"

"The art and manners are something I have to study everyday."

Question: You danced in the "Prelude" of the 2007 *Miyako Odori* on some days, and you played the drums on other days for the same dance. What comes first, learning the dance or learning the music?

Satomi: "I memorize the dance from the words of the song, and I learn the drum by the sound of the samisen since we all practice at the same time. I learn ohayashi by the book."

Satomi in *Miyako Odori*

Question: What do you mean by "I learn the drum by the sound of the samisen"?

Satomi: "I think everybody has a different method, but in my case, I memorize the timing of the drum by listening to the call of the onesan who is playing the samisen."

Question: You also performed in the third dance of *Miyako Odori*, "Hikone Folding Screen." Who was the character you portrayed?

Satomi: "My role was a *yujo* (an entertainer)."

Satomi in "Hikone Folding Screen"

"My part was a dancer in the story."

Question: In your *Miyako Odori* performances, you used several different fans. Are there names for the different techniques of using a fan?

Satomi: "It depends on the role and the scene. I don't know the names of them. I simply follow the teacher's instructions."

"This is a scene about plum blossoms. I am a very slow learner, so it is hard for me to remember the movements."

Question: So the fan techniques are just another part of the dance?
Satomi: "Yes, I learn them as a part of the dance."

Satomi in "Cherry Blossoms in the Kinkakuji Temple"

Satomi in "Autumn Color Leaves at the Jojakkoji Temple in Sagano"

Question: Besides a fan, you used other props like a basket and a scarf while you were dancing. Do you enjoy dancing with props, or do you prefer to dance with just hand gestures?

Satomi: "The props probably help to express the seasons or help to express the character's facial expressions. With or without them, I like to dance, so it really does not matter."

"I put my scarf on my head and pretend my sleeve is a piece of paper for writing a letter. Now I am about to write the letter."

"The props probably help to express the seasons or help to express the character's facial expressions."

Question: You also performed the tea ceremony during *Miyako Odori*, and I noticed that your hair was styled differently. You weren't wearing a katsura, and you had kanzashi in your hair like a maiko. Can you tell us the name of this hairstyle and the reason for the kanzashi?

"At *Miyako Odori*, I sometimes get to do the tea ceremony for guests. This is a shot backstage. This hairstyle is made with my own hair, not a katsura."

Satomi: "We call it, only amongst us, the hairstyle for the tea ceremony. The hair ornament is a special style for this dance."

Question: You wore your kimono differently on the day of the tea ceremony as well. Your collar was folded so we could see a splash of red. Do you know what this means?

Satomi: "I guess it brightens the face. I never really thought about it since I don't dress myself."

Question: When you do wear your katsura, I notice that you always have a thin red wire in it, just in front of the comb. What is this called?

Satomi: "It's a red *mottoi*."

Question: Can you describe what a typical day is like for you? For example, how much time do you devote to dance and music lessons?

Satomi: "Practice is about one week out of a month, except the time we practice for *Miyako Odori* or *Onshukai*. I practice until I remember."

Question: What do you enjoy most about being a geiko?
Satomi: "The recitals. *Miyako Odori*, *Onshukai*, and a recital for the *taiko* (drum)."
Question: What adjustments did you have to make when you went from being a maiko to being a geiko?
Satomi: "Life in general. When I was a maiko, I only had to think about practice. However, once I became a geiko, making a good rapport with my peers and the ochaya became important."

"This pose is from a dance called 'Higashiyama Meisho,' my favorite. Here I am peeping at a child next to me."

Question: How has your understanding of a geiko's art deepened since you became a geiko?

Satomi: "I could have been more enthusiastic about the art when I was a maiko. The art and manners are something I have to study everyday."

Yukako

Shikomi are the girls in training to be maiko. Since they are usually dressed in blue jeans and t-shirts like most young teenagers, they blend in with the crowds of tourists who converge on Gion Kobu almost every afternoon. One way to tell shikomi from typical teenagers is that they are usually in a hurry. If you see a girl rushing down a side street carrying a geiko's umbrella or following a maiko down Hanami-koji, the main street in Gion, you've spotted a shikomi.

The first shikomi I ever met was a girl named Momo. I noticed her because of her pigtails. She wore her long, lustrous hair in pigtails that bounced whenever she trailed behind a maiko or geiko. I didn't realize it at the time, but one of my favorite spots in Gion was between her okiya and the house where one of her onesan lived. So, Momo would sometimes pass by me two or three times in a single afternoon while she ran errands, and we just naturally started greeting each other.

Momo impressed me because she was more mature and outgoing than most of the other shikomi I encountered. Once I got to know her a little, I would ask her a question or two in English to see if she understood me or tease her by telling her she'd better hurry or she'd get in trouble. I started off with the most fundamental of all questions, "How are you?"

"This month's kanzashi is the Chinese bellflower. You can tell which month you saw a maiko by these seasonal hair ornaments. The Chinese bellflower is a flower of September."

81

"I will always strive to make my art better even after I become a geiko."

I was taken aback when Momo quickly responded, "I'm fine, thank you. And you?" Every junior high school student in Japan is taught this stock reply, so I wasn't surprised by her words. What stunned me was the way she said them, with a forcefulness and determination to say them correctly that is quite rare in someone so young. It was clear to me then that Momo was a very dedicated girl.

One day months later I was standing in another of my favorite spots in Gion when I heard the familiar clip-clop, clip-clop of a maiko's okobo behind me. I turned around and saw a maiko I didn't know walking down another side street. She stopped when she saw me and bowed in greeting. I was wondering who she was and why she was acknowledging me when I suddenly recognized her. It was Momo! She had finally become a maiko. A few nights later I literally almost ran into her near Ichiriki. I congratulated her and learned that her new name was Yukako. The pride glowing in her beautiful brown eyes and the happy lilt in her voice when she thanked me are things I will never forget.

It is wonderful to see someone's dream come true. It makes you realize that anything is possible, and maybe your own dreams can become a reality, too.

I have photographed Yukako countless times since she was a first-year maiko in 2004, but my favorite image of her is in my memory, not on film. I was photographing her at Ofuku, one of my favorite ochaya, in September 2007. We were trying to capture the most memorable moments of her favorite dances for this book, and we had just taken a short break. Yukako was going through the *kata* (forms) of a dance by herself. Her eyes were open and there was a bemused smile on her face, but she wasn't looking at anything around her. She was in her own world, and in that world she was dancing. She looked so happy that I couldn't help but smile myself.

"My scarf has the crest of my okiya and my name, Gion Yukako. Once I become a geiko, the color of my scarf will be purple instead of red."

83

Yukako is now a veteran maiko. Somewhere along the way the cute young girl I knew became an elegant young woman. I think of them both with great fondness.

Question: Yukako-san, you were one of three Gion Kobu maiko to dance at Yasaka Shrine during *Setsubun* in 2007. Could you tell us the name of the dances and who taught them to you?

Answer: "The first song was '*Matsu Zukushi*,' and it was taught by *Shisho* Kazue-san. The second was '*Gion Kouta*,' and it was taught by *Shisho* Yoko-san."

Question: Since you were dancing with two other maiko, you had to master the moves of the dance yourself and also make sure your timing matched the others. How do you do it?

Yukako: "I follow the lead of the samisen. I don't look at the other dancers, but I try to listen to the music. Where I have to stand up and sit down when there is no sound, then I look at the eldest onesan out of the corner of my eyes to follow what she does. You don't need to turn

around and look at her. I should be able to sense onesan's movement."

Question: At a key moment in "Matsu Zukushi" you hold the fan above your eyes and gaze into the distance. What are you supposed to be looking at?

Yukako: "I think this is where I look at a pine tree in the great distance. I screen my eyes from the light with my hand."

Question: Your kimono's long sleeves play an important role in your dancing. At one point in the dance, you are holding your sleeves in front of your face so we can only see one of your eyes. At another point, you have your arms folded in front of you. Then, you are holding one sleeve up to your mouth as you look into the distance. Can you explain what these gestures mean?

Yukako: "These are poses from 'Gion Kouta.' The first two photos show where the words of the song are 'I am longing for Gion.' The pose in the third photo occurs when the lyrics are 'I put my unfinished feelings about a loved one under my sleeve.'"

Question: Your hands were also used quite expressively. In the next photo, one hand is in front of your heart and the other is holding your kimono, and both hands are placed very precisely. In the photo after that, you are waving your hands in front of you, as if you are beckoning someone. Why is the position of your hands so important?

Yukako: "It is all from the Inoue School dance style. I am not one hundred percent sure, but the photo where I am holding my kimono may represent cooling off by dipping one's feet in the river in summer. The gesture when I am waving my hands always means a mountain."

Question: Do you enjoy dancing with props like a fan, or do you prefer dancing without them?

Yukako: "It is not about the things you dance with. It is more about the number itself. For example, in '*Higashiyama Meisho*,' there is a prop for this number. When I dance this song, it is not that I enjoy what I dance with – I enjoy the music and dance all together as a whole. First, the dance, then it happens that I have some props to dance with, and when the season changes, the prop changes as well."

Question: In the 2007 *Miyako Odori*, you performed in two different dances, and I believe you also played a musical instrument on some days. How did you prepare for three different performances like this?

Yukako: "I started the instrument practice in February, and I started learning the two dances simultaneously in March."

Question: Which of the dances was your favorite?

Yukako: "I like both dances. It is my joy to perform and show the audience what I have accomplished."

"Just like a scarf, a red fan becomes purple once a maiko becomes a geiko. Gion geiko receive a fan with the crest of the Inoue School in the center when they have their omisedashi or erikae."

Question: In the dance "Watching Fireflies in the Kiyotaki River," you use both a round basket and a tree branch as props. What are they for?

Yukako: "The basket is a cage for fireflies, and the bamboo shoot is used to catch the fireflies."

Question: How many dances do you think you have learned since you became a maiko?

Yukako: "Before I made my debut as a maiko, I learned ten songs. After becoming a maiko, I learned about ten more songs."

Question: What is a typical day's schedule like for you?

Yukako: "It depends on the day. There is dance class, tea ceremony class, instrument class, samisen class, calligraphy class, painting class, Noh dance class… I have something five days a week. When I have a lot on one day, I spend my time from 9:30 a.m. to 2:30 p.m. for lessons. When we practice for *Miyako Odori*, it won't finish by 2:30.

"This is a photo of *Miyako Odori* in 2007. This scene represents summer. I have a cage to put insects in. There was a part when I was very scared because I was wearing okobo on the stage and had to run backward."

91

"I get up in the morning, adjust my hair, put my kimono on, and then go to classes. After I come back from classes, I eat a meal and then start to put white on my face two hours before I go to work. After the powder, I have the *otokoshi* (kimono dresser) put my kimono on, have a light supper, put lipstick on, and then go to work. Normally the curfew for maiko is about 1 a.m., so the house will call to remind me. I go to bed around 2 a.m. When I have work in the morning, then all the things I do in the afternoon are switched to the morning."

Question: You made your debut in the spring of 2004, so you have been a maiko for more than three years now. How do you think you have changed in that time?

Yukako: "I still have a lot to learn. So, really, I don't think I have changed much. However, some people who have known me since my debut have been telling me that I have matured lately. When I was sixteen or seventeen years old, I simply did what I needed to do in a blind effort, but lately I have been a lot calmer and mentally more relaxed."

Question: What do you like most about being a maiko?

Yukako: "By being a maiko, I have a lot more chances to talk to people that normal teenagers would not come across, and I am more exposed to a lot of different things. I truly appreciate that."

"In Jidai Matsuri, I was a part of *Heian Fujin Retsu*. This was my first time wearing a wig. I was very excited that morning since I dressed up very differently from my usual kimono."

"Every August 1 in Gion we have a ceremony called *Hassaku*. On that day, we wear black kimono made of a cloth called *ro*. I have a tortoiseshell comb in my hair."

93

Question: I'd like to talk to you about how you put on your makeup. You touch up your lipstick with a small brush. What is that brush called?

Yukako: "It is a *benifude* (lipstick brush). I don't do anything special, but I put powder on occasionally. We don't use the same kind of makeup that regular girls use. We use hair oil (not a water-based oil) as the base of our make-up."

Question: Do you have a favorite dance?

Yukako: "I like *'Momiji Gari'* ('Admiring Maple Leaves') for autumn. This dance is only for a limited season, though. For summer numbers, I like *'Hotaru Gari'* ('Firefly Hunting')."

"It is my joy to perform and show the audience what I have accomplished."

Question: What kind of song is the hardest to memorize?

Yukako: "Let me see... If it is an uneventful song with samisen, without any climax or change of tones... However, if there is some theme or meaning in the song, then it is easier to memorize. But something I don't even understand, then, it is extremely difficult. Without props, how much more difficult it would be to memorize since all these songs are sung in classic Japanese."

Question: Is there anything else you'd like to say to the readers about a maiko's art?

Yukako: "It has been three years since I became a maiko. Many of my peers have gone already. There was a time when I thought it was difficult, but I have been enjoying it more now. I will always strive to make my art better even after I become a geiko, and I would like to stay attractive as an artist and as a person."

Makiko

When I think of Makiko, I think of her smiling.

A few months ago was *Hassaku*, an event held every August 1 in Kyoto's hanamachi. It was an incredibly hot day – as most days are in Kyoto in August – and there were hundreds of people with cameras waiting everywhere to get snapshots as the geiko and maiko of Gion Kobu made their rounds of the ochaya in the district to show their appreciation for all the help they have received during the year. I was suffering from the heat, so I can only imagine how difficult it must have been for Makiko, dressed in a black kimono and with a long white and gold obi wrapped around her.

Makiko and her sisters (including Yukako) walked from ochaya to ochaya for about two hours under the blazing morning sun with people blocking their paths pretty much every step of the way. So, when I first saw the photos I took that day, I was surprised to see several with Makiko smiling at me or waving to me when she glimpsed me among the crowds.

Then I thought about it, and I realized I cannot remember a single time when I have seen Makiko that she hasn't been smiling. I also realized that these photos remind me of why I think Makiko is so unique: her sense of self and her thoughtfulness.

I have known Makiko since she was simply Maki (her real name), a new shikomi in Gion Kobu. From the first time I met her when Momo introduced us (Yukako and Makiko both belong to the same okiya and were shikomi together for a time), she seemed completely at home in Gion. I didn't sense any nervousness or trepidation from her at all. She seemed to know who she was, and she was happy where she was. I think her smile is a sign of that.

More importantly, Makiko is conscious of the people around her and how they feel. I remember one particular encounter we had when she was just a shikomi. She saw me on a Saturday afternoon when I was waiting at my favorite spot at the intersection of Aoyagi-koji and Nishishochiku-koji, and she told me that if I stayed there for about another half hour, a maiko or geiko would come by and I could get a photograph. She was probably only fifteen at the time. Her mind must have been filled with all the chores she had to do, but she was perceptive enough and thoughtful enough to think about what I was doing. No one else ever tried to help me like that.

Moreover, when I started work on this book, I gave each maiko and geiko the photos from our first sessions so they could see what I was trying to accomplish. Makiko was the first to contact me to thank me for the photos and tell me how beautiful she thought they were. Such thoughtfulness and consideration are a rare form of beauty that few possess, particularly the young.

And that's why I smile whenever I think of Makiko.

Question: Makiko-san, what made you decide to become a maiko?

Makiko: "I always wanted to earn my living with some performing art, probably because of the influence of my sister, who is ten years older than I am. She already works as a great performer. I have an older brother, by the way, but I have always admired my sister. So, when I saw a maiko in Kyoto, I thought becoming a maiko would be a great idea. Then I watched a documentary on maiko after visiting Kyoto, and I saw that the featured girl was the same age as I was. Then

I really started thinking that I want to do that, too.

"My final decision was made when I was in junior high school. I was lucky to have someone who recommended me to Gion. I was curious about college life as well, but I only have one life. So, I wanted to do something interesting with my life and made the decision to be a maiko."

Question: What does your sister do?

Makiko: "She belongs to the Takarazuka Review (a famous all-female theater group) as a male-role performer. She is very tall – unlike me – about 170cm. I always go see her performances with my mother. After I started my career as a maiko, I found a lot of similarities between the world of Takarazuka and Gion when I talked to my sister. They are both women's worlds, and there are always classes we have to go to…"

Question: The first time I photographed you dancing was at the 2007 Kyoto *Higashiyama Hanatouro*. What was the name of that dance, and how long did you practice until you were ready to perform?

Makiko: "The name of the dance is '*Hanagasa*.' I dance this number a lot at ozashiki, so I don't need to practice much."

Question: Who taught you the dance?

Makiko: "The teacher is Sensei Inoue Yachiyo."

Question: In the first section of "Hanagasa," you were holding two circular discs while you danced. What do they represent?

Makiko: "These discs are also called hanagasa. It's a hat with flowers on it that sort of worked like an umbrella back then. It represents fully blooming cherry trees, I believe."

"This is a dance called 'Hanagasa.' We use two little umbrellas with flowers and bells. It is very much a dance for spring."

Question: In another section of the dance, you were kneeling and looking down at your hands. What do those gestures mean?

Makiko: "I was playing a woman pulling her mirror out and adjusting her kimono and hair."

"I always wanted to earn my living with some performing art."

Question: You were gesturing as if you were pulling a pin out of your hair in a third section. What is that part of the dance called?

Makiko: "It is a song called 'Gion Kouta.' It's a scene from autumn."

Question: In the 2007 *Miyako Odori*, you danced on some days and played the flute on others. Do you prefer dancing or playing an instrument?

Makiko: "I like both. I enjoy dancing a lot, and I also love playing the flute."

Question: You danced in one of the most famous scenes of *Miyako Odori*, "Autumn Color Leaves at the Jojakkoji Temple in Sagano." You were wearing a scarf, and you were again making very specific gestures with your hands. What did your gestures signify there?

Makiko: "Striking a *sumi* (an Indian ink stick) and writing some letters with a brush."

Question: Do you have a favorite dance?

Makiko: "My favorite dances are '*Higashiyama Meisho*' ('Places of Interest in Higashiyama') and '*Kyo no Shiki*' ('Seasons of Kyoto')."

"This is the gesture of grinding an ink stick."

Question: Is there a dance you find particularly difficult to perform?

Makiko: "I get nervous with the celebration dance. We use two fans, and we need to whirl these fans at the same time. Since it is a dance dedicated to an auspicious occasion, I cannot make any mistakes. However, the risk of an error is substantially high. It surely looks spectacular, but for me, I am extremely nervous. For example, at a marriage ceremony, a reception party, or the anniversary of the founding of a company, we are often requested to dance *'Kimini Ougi.'* It requires two fans. It is a very popular performance for our age group. There are certain songs that only maiko can dance or only geiko can dance. I can only answer from what I have already learned out of our repertoire."

Question: Many people don't realize that maiko spend a great deal of time in dance and music lessons. How much time each day is devoted to learning your art?

"The crest in the center of the fan is the crest of the Inoue School."

Makiko: "It depends on the day. Since I am a tachikata, my main day-to-day training is for dance, but I also learn to play the samisen and the Japanese flute, or calligraphy. I was once told it does not matter whether I am good or bad. What is important is the spirit of wanting to learn. For example, if you are learning the hand drum, then when you go see the ohayashi, you can admire the players. To be honest with you, I am swamped with practices. *She laughs*.

"When we have an event like *Miyako Odori* or some other dance event, then there will be more practices and lessons. So, classes take place earlier in the morning. It is hard, but this is how we get to practice. Normally, the masters are off on Sundays, so we don't have a class then. But the closer it gets to the event, then no more Sundays off! *She laughs*. It is hardest before *Miyako Odori*."

Makiko in Jidai Matsuri

Question: When I first met you, you had just arrived in Gion Kobu and were a shikomi. What do you remember most clearly from that time?

Makiko: "When I first came to the okiya, I had a lot of different feelings all at once. I was nervous, and very anxious, but also very happy. I felt sad to leave my family. However, okasan and onesan were so nice to me. Since it was a very cold day, I cannot forget the delicious warm *udon* I had on that day."

Question: How does being a shikomi prepare you to be a maiko?

Makiko: "My older sisters and okasan taught me about the customs of Gion, dancing, the dialect of Kyoto, and more. Besides those, they taught me manners and how to behave with my elders. They taught me the basic manners needed to be able to become a respectable person."

Question: Can you give an example of the manners you were taught?

Makiko: "For example, before you touch the food you are served, you do not forget to say, 'Thank you, Okasan. *Itadakimasu*.' Kids these days tend to forget these super basic manners. And even when it is common sense basic manners, you will be thoroughly taught once you come to an okiya. And these things are very important."

Question: As you've mentioned, you live at an okiya away from your real family. Is it hard to live communally?

Makiko: "I have a sister and brother, so it is not that hard to share and live with other people. It may be harder for a girl who is an only child since she never experienced living with many other people. As for me, my real home is very close by, so if I want to, I can go home every night. However, because it is a rule not to go home, I have come to feel that the okiya is my home.

"This is the gesture of a girl crying. This pose is used a lot in many different dances."

"On my tenugui (scarf), it says Gion Makiko. There is normally a family emblem in the center of the tenugui, but the crest of an okiya is there instead when a girl is a maiko."

"In the beginning, I was a little homesick. I thought, 'Why can't I just go home and sleep and come back the next morning?' After all, I got used to the town and don't get homesick all the time. I can even think that Gion is my home ground. I feel the girls around me are real sisters. Now the room I have is my nest. *She laughs.*

Question: Do you have your own room?

Makiko: "I share with Yukako-onesan. There is no clear border about which part of the room is mine or hers. We went out to get a boom box for the room together to listen to music. It is the most comfortable and relaxing space. This is the place I come back from work and unwind by talking to Yukako-onesan, and in the morning we put makeup on. It is the most homey space of all. Yukako-onesan takes good care of me. She tells me that I don't have to worry about anything there. I can just be a vegetable once I am in that room."

Question: You will be living with other maiko after Yukako leaves, right?

Makiko: "Yes. From the oldest, there is Yukako-san, me, Saki-chan, Keiko-chan, and a new shikomi. Every year a new shikomi comes. They all grow up by watching onesans. After Yukako leaves, I have the responsibility to take care of them just like Yukako did."

Question: What were your first few months as a maiko like?

Makiko: "I had no idea what to do at all! I was doing whatever I was supposed to do for my life, and the time flew by. I could not put white powder on well at that time, so I studied a lot by looking at how my older sisters do it and pictures of actors. Anyway, I was in bliss to be a maiko because that was what I had dreamt of."

Question: How do you feel now that you've been a maiko for a few years?

Makiko: "I could not afford to think about anything else at the beginning stage of being a maiko, but now I can think about my future goals and I can think about the needs of others. Now I can think about what other people think about. Finally, finally, I am settling down."

Question: What qualities does a young girl need to be successful as a maiko?

Makiko: "What I always try to remind myself is to think what others need. For example, if onesan seems to be thirsty, you get her something to drink before she realizes that she is thirsty. You have to be able to read the atmosphere, meaning you have to be sensitive to what others need. You have to act before anybody else does something. This is the thing we were taught all the time. Eventually, this skill will be applied to the services for the customers."

Question: These things are very difficult to know and understand when you are a teenager, aren't they?

Makiko: "Living together with a lot of other girls and okasan and other people around, you naturally understand these rules."

Question: I'd like to talk a little bit about your hair, makeup, and kanzashi. You use a very unusually shaped comb on your hair. Does it have a special name?

Makiko: "It is a comb used in summer called *makigushi*. It takes one hour for me to do my hair, so I have to keep the hairstyle for a while. Every morning when I comb my hair, I use *bintsuke* oil to make my hair look glossy and to hold it together neatly. Maiko always carry a mirror and a *naginata* comb for whenever we need to fix our hair."

"What is important is the spirit of wanting to learn."

Question: I've taken portraits of you in several different months, and in each photo your kanzashi are quite different. What are the names of the different ornaments?

Makiko: "The flower in the first photo is *ume* (plum blossom). The second photo is *susuki* (Japanese pampas grass), and my hairstyle is *yakko shimada*. The last photo is a flower called *hagi*. When a maiko is more experienced, the kanzashi become simpler. She also wears a white collar with embroidery to emphasize a sharper and cleaner image."

Question: The second photo was taken during Hassaku. What is that?

Makiko: "When the sun is still high in the middle of the day on August 1, maiko and geiko visit their teachers and okiya to do the seasonal greeting. We wish them happy summer days and ask for their continuous and everlasting support. In Gion, we wear black kimono with an embroidered crest on this day. This is the only day during the summer when we wear this kimono."

Makiko in February 2007

Makiko during Hassaku

"This is the gesture of hiding herself behind her sleeve."

113

Question: You often have an ornament shaped like a blue and gold heart in your hair as well. Where did you get it?

Makiko: "The one with hearts is called *bira-dome* or *maezashi*. I usually use maezashi that were a gift from my onesan or okiya, or one I personally picked. This maezashi is one of four – each with different colors – that I got with Yukako-san-nesan and two other maiko. I keep it dearly."

Question: You have been a maiko for four years already. What is your goal?

Makiko: "Well, so far as a maiko, I have managed to come this far with all the practices and classes without thinking much about anything else. However, now that my closest onesan is going through erikae, it struck me. I came this far. I have to be more responsible and better in order to have my erikae. I want my erikae to be celebrated by everybody and blessed by everybody."

Question: What would you like to do after you become a geiko?

Makiko: "The apprenticeship won't be over even after I become a geiko. In order to be jimae (independent), I will practice more like onesans and have to be stricter with myself. I want to be able to see more around me. It all comes down to that I have to have space in my mind to be able to do all that."

Question: What would you like to do in the future?

Makiko: "Some maiko go abroad, others get married or go to college. There are many different ways to go. I do wonder what it would be like to go to college or to be married and have some children. However, I love this town, and being here, I get to meet a lot of interesting people. To attend a party is my job, and to dance on stage is my job as well. To be a model for photography or paintings is also my job. I get to do many different jobs just by being a maiko. So, since I can be a maiko and at the same time do all these various kinds of jobs, I want to be a geiko and stay in Gion. I cannot think of anything else I want to do right now."

Question: Is there anything else you'd like to say to the readers?

Makiko: "Yes. There are a lot of traditional things, which have been passed down from generation to generation like *pocchiri* (an ornament that goes in the front center of an obi), ornamental tortoiseshell hairpins, Gion's annual events and customs… I strongly hope all of these traditional values and cultural treasures will be passed on to generations to come. I am totally committed to working hard in order to save these historical treasures and customs. I would love to have more and more people come to see our performances like *Miyako Odori* and other events that are open to the public."

Makiko in May 2008

Last Days as a Maiko, First Days as a Geiko

On May 26, 2008, Yukako had her erikae and became a geiko. The term erikae literally means changing the collar, and it refers to a fundamental difference in the appearance of maiko and geiko. I first photographed Yukako in September 2004, a few months after her debut as a maiko.

Like all new maiko, her collar is a mixture of red and white, and only her bottom lip is painted red. As a maiko gets older, less and less red appears in her collar, as can be seen in this photo of Yukako taken three year later, in September 2007.

Her collar is white, but not yet plain white. There is a delicate pattern embroidered in the material. When a maiko becomes a geiko, she leaves behind the more colorful and ornate collars of a maiko and replaces them with a collar of pure white cloth.

Yukako's erikae began a few minutes after noon when she stepped out of her okiya for the first time as a geiko. There were about twenty photographers and onlookers waiting for her to make her first appearance, and she posed for photographs for a few minutes.

However, a few seconds after she appeared, the katsura maker followed her out and asked her to wait for a moment. He wanted to make a few last-minute adjustments to her new wig.

When the katsura maker finished, Yukako began her trip around Gion Kobu accompanied by an otokoshi. Among other things, an otokoshi's job is to help a maiko put on her kimono and long obi, known as a *darari no obi*.

Yukako and the otokoshi made the rounds of Gion Kobu's ochaya, and Yukako was introduced at each as a new geiko. Her first stop was Ichiriki, Gion's most famous ochaya.

After visiting Ichiriki, Yukako paused at Gion's busiest intersection, the corner of Shijo and Hanami-koji. As she waited for the traffic light to turn green, she posed for her first close-up portrait as a geiko.

"Everything is all up to how much effort I make and how much I can be sensitive to the needs of others."

For the next two hours, the same pattern was repeated countless times. The otokoshi would escort Yukako to an ochaya, hold the door open for her, follow her in, and close the door behind them. A minute or two later, they would reappear and make their way to the next ochaya.

Most of the time, Yukako's face remained expressionless, but she would occasionally meet someone she knew and her true feelings would be revealed for a second or two. These are the moments I remember most from her erikae.

It was a particularly busy day in Gion. Yukako was having her erikae,

there was another geiko in Gion Kobu making her debut, and there was also a television crew filming on Aoyagi-koji. At one point, Yukako and the otokoshi had to wait patiently for the television crew to finish a take before proceeding down the street.

A little more than two hours later, Yukako returned to her okiya and followed the otokoshi back inside. She had been introduced to the ochaya in Gion, and she was now officially a geiko.

In addition to photographing Yukako on the day of her erikae, I also photographed her four days before the event when she was still a maiko. Then I photographed her one more time five days after she had become a geiko. At that final session, I asked her about her last days as a maiko and first days as a geiko.

Question: How long did you prepare for your erikae?

Yukako: "A maiko becomes a geiko when she is twenty years old. So, it is expected when you turn twenty, but we do not prepare for such a long time since the okiya starts to think about when to do the erikae or what kind of *montsuki-kimono* (a kimono with a crest) we need to prepare. We won't know about the props until very close to the erikae period. Also, there are other things occupying our minds like *Miyako Odori*. So, we usually let the okiya handle the erikae preparation."

Yukako four days before her erikae. Since she will soon become a geiko, she is no longer wearing a pocchiri on her obi.

Question: Does your preparation begin when you first wear the *sakko* hairstyle?

Yukako: "It starts before that. I wore the *yakko* hairstyle for a week before wearing the sakko hairstyle for two weeks. Then I had one day off. The next day was the actual erikae."

The sakko hairstyle from the right

The sakko hairstyle from the left

133

Question: What is the difference between sakko and other maiko hairstyles?

Yukako: "The sakko style was for young newlywed housewives. Now only maiko wear that hairstyle before they become geiko. In Gion, we wear sakko for two weeks. It varies in each district. You can tell this hairstyle by looking for the little tail of hair hanging behind the buns."

Question: What is a *takamakura*?

Yukako: "A maiko uses her own hair for her different hairstyles. Once the hair is set, it has to stay in place for a week. In order to keep the hairstyle neat, she has to sleep with a takamakura, which is a little box with a small cushion on one side made with buckwheat chaff."

Question: You sleep on the takamakura?

Yukako: "Yes. You get used to it. I could not sleep in the beginning, though."

Question: So you cannot move your head when you sleep?

Yukako: "Well, no. It is impossible. However, it is a necessary technique for us to learn how to fix our hair in the morning every day."

The sakko hairstyle from the back

Question: When you wear the sakko hairstyle, you also wear a black kimono. Then you use *ohaguro,* which dyes your teeth black. Why?

Yukako: "Back then, becoming a geiko meant that a maiko had a male sponsor (which was regarded as her having a husband within the hanamachi), so she became an adult. Now, that kind of tradition is gone. We just become geiko because of our age. But back then, after people got married, a woman had black teeth. So it has the same meaning as wearing the sakko hairstyle."

Question: When I took your photograph when you had the sakko hairstyle, I thought you might be a little shy about your black teeth, but you weren't at all.

Yukako: "I was not ashamed to have black teeth. I have been a maiko dreaming of wearing this style one day since this is the formal style to be a geiko. I kind of felt like 'I've finally made it.' I also simply like the style."

Question: How did you feel during your last few weeks as a maiko?

Yukako: "I was mentally driving myself up the wall before starting the sakko style, but after the first day of wearing sakko, everybody seemed to be in the sprit of a happy ceremony. So, I was very happy and finally relaxed for those two weeks.

"The very last day of sakko, we have a little ceremony around midnight. It's just like sumo wrestlers have their *danpatsu* ceremony when they retire. We have a cutting hair ceremony as well. I could not see my hair being cut off by each member of the okiya, but I could feel it through my skin. I felt a strong emotion thinking that I am never going to have someone do my hair again."

Question: Did a *kamiyui* (personal hairdresser) cut your hair?

Yukako: "No, onesans and everybody else did. It felt like this is the end of my time as a maiko."

Yukako's teeth are dyed black with ohaguro.

Question: How did you feel on the morning of your erikae?

Yukako: "The night before was the first day for me to use a regular pillow. I was thinking, 'At last I can sleep,' but every hour I woke up and thought of things like 'Would my new geiko wig look good on me,' or if it was going to rain. I did not get enough sleep after all."

Question: Your katsura is very different from your maiko hairstyle. What is the biggest difference for you?

Yukako: "Once I had my maiko hairstyle, I could not undo it for a week, but a katsura can be taken off at the end of the day. The wig is lighter than people think, and since it is custom made, it fits right on my head."

Question: It is a little heavier than your own hair, right?

Yukako: "Right. The thing is, I could fix my maiko hairdo with my comb, but I cannot do anything with the wig myself. So I have to be very careful with it."

Question: You don't have many wigs?

Yukako: "No. This is going to be the only one. I send it out once a month for them to redo the wig for maintenance. Unless it is totally damaged, it will be the only one."

Question: You put your katsura on by yourself?

Yukako: "Yes."

Question: When you walked through Gion Kobu with the otokoshi, you seemed to be having a lot of fun. What were you talking about?

Yukako: "Various things. Like, 'Oh, it is so hot we will be dehydrated.' Or I asked him about the past. For example, 'How many otokoshi did Gion used to have?' or 'On the north side of Gion, there are not many ochaya. How many were there when *onichan* (the otokoshi) became an otokoshi? Were there more of them?' Things like that."

Yukako performing the dance *"Kurokami"* ("Black Hair") five days after her erikae.

"Kurokami" is a dance performed by new geiko.

Question: What does an otokoshi do in general?

Yukako: "He puts a kimono on a maiko. We call it *shikiri*, which is basically the work a manager of a talent agency would do. However, they belong to the union and probably get the salary from them, but at the same time they get a salary from the okiya as well. It is more like a family related business since otokoshi are not really coming from outside. They usually come to this world through connections since the trust issue is highly important. He has to put a costume on the girls, and he goes in and out of the house (okiya) dealing with money as well. At the same time, an otokoshi is a job where he needs to serve girls. It has to be one of the toughest jobs."

Question: What do you remember most about the day of your erikae?

Yukako: "There is a long-time client of mine who has known me since I was a maiko. He came to see my first day. However, he did not recognize me until I went right next to him and said, '*Ookini*.' I was amazed to realize how big a difference it is to be a geiko. That was when I started to think about my responsibility."

Question: It has only been six days since you became a geiko. How do you feel so far?

Yukako: "Right now, it is still the introductory stage of being a geiko, so I am taken to a lot of places and also called to ozashiki. However, after this period is over, it will be all up to my effort. Everything is all up to how much effort I make and how much I can be sensitive to the needs of others. It will be a test for me since the things that count from now on are my competence and ability.

"At the end of my time as a maiko, I did not have enough space in my mind to do anything, so I want to take more time to do various things. I mean, if I run around like a chicken without a head, I am sure that will

affect the people around me. So mentally, I want to slow down and learn a lot more to grow."

Question: Is life as a geiko much different from what you expected it to be?

Yukako: "Everybody is complimenting me about my geiko look, but right now my status is that of a new geiko in the process of changing to be a real geiko. So I will keep the freshness for a while and try to take time to grow up as a geiko."

Question: What will you miss the most about being a maiko?

Yukako: "What could it be… Maybe the hairstyles. I really liked having a kamiyui do my hair. I won't have that done anymore since I will wear a wig from now on. And the darari no obi. It is heavy, but there is a pose in the song 'Gion Kouta' that I will miss since I won't be dancing that part anymore in the future."

Question: What are you looking forward to most as a geiko?

Yukako: "I am looking forward to seeing how I look with a Western hairstyle while wearing a kimono like onesan are doing. Also, I will be able to go on business trips on my own as a geiko, and there will be a lot of occasions to wear Western clothing to go out."

Question: Kimono are very expensive. Do you have any anxiety about preparing all your kimono on your own after you become jimae?

Yukako: "It will be two years from now until I become completely independent as a jimae geiko. Two years from now, I am not sure what it will be like with me. However, the okiya has prepared enough kimono for me to go on for at least a year. While I can still depend on them, I will do so. After that, little by little, I will make my own way. Otherwise, I will be the one who has to pay for it all in the end. I have to be strong and focused."

Question: What is your goal now?

Yukako: "There is something I should not forget. I came to live in an ochaya when I was fifteen years old. All I know about is strictly limited to the town of Gion. The common sense here could be totally illogical in the outside world. I always have to remind myself that. Of course, I have pride that I am a geiko of Gion, but this is not made by me. All my seniors created the tradition and reputation of Gion. I have to do my best not to degrade that. At the same time, I want to establish my own individuality. I am looking forward to doing things I could not do as a maiko."

A few weeks before Yukako had her erikae, I asked Kimina what she remembered about her first days as a geiko. Her experience was quite different from Yukako's.

Question: Kimina-san, Yukako, a maiko from Gion Kobu who is also going to appear in the book, is having her erikae this month. What do you remember about the day you became a geiko?

Kimina: "I felt totally different from how Yukako-san feels. It is more like her misedashi as a maiko and my misedashi as a geiko would be closer in feeling. So, our feelings are totally different. As for me, after I did misedashi as a geiko and went through some years of living at an okiya and then became on my own, I still did not have any ceremony like erikae. I was just told, 'You will be on your own from next month.' *She laughs*. As simple as that. No words like, 'You will be all by yourself from next month, so devote yourself to your new life. Do your best!'" *She laughs again*.

"Only the girls who have been through being a maiko would know how Yukako feels. It is probably similar to being on your own, but after being a maiko for a certain number of years, she is closing the curtain on one segment of her life. From now she starts a new segment of life."

Question: Kimina-san, do you have any advice for Yukako since you have seven or eight years of experience as a geiko?

Kimina: "Yukako should keep what she has learned and what she has done with her, and take time to be grateful for all the things others have done for her. It is a new start. As a maiko, she was taken care of by the mother of a house. I know after becoming a new geiko she still has to live at the okiya for some years, but she will have to take care of her junior fellows as a geiko."

Question: How long does a geiko have to be at an okiya before becoming independent?

Kimina: "In Miyagawa-cho, normally it will be at least three years, and five years is standard before we become independent as geiko."

"I have been a maiko dreaming of wearing this style (sakko and ohaguro) one day since this is the formal style to be a geiko."

144